Bee Happy!

Bee Happy!

Wit & Wisdom for a Happy Life

Maryjo Koch

Andrews McMeel
Publishing®

Kansas City · Sydney · London

Bee Happy! Wit & Wisdom for a Happy Life copyright © 2014 by Maryjo Koch and Jennifer Barry. Artwork copyright © Maryjo Koch. All rights reserved. Printed in China. No part of this book may be used or reproduced in any manner whatsoever without written permission except in the case of reprints in the context of reviews.

Andrews McMeel Publishing, LLC
an Andrews McMeel Universal company,
1130 Walnut Street, Kansas City, Missouri 64106

www.andrewsmcmeel.com

Concept and Design: Jennifer Barry Design, Fairfax, California
Editorial assistance: Jody Sela and Blake Hallanan

14 15 16 17 18 SDB 10 9 8 7 6 5 4 3 2 1

ISBN: 978-1-4494-4710-6

Library of Congress Control Number: 2013951357

Attention: Schools and Businesses
Andrews McMeel books are available at quantity discounts with bulk purchase for educational, business, or sales promotional use. For information, please e-mail the Andrews McMeel Publishing Special Sales Department: specialsales@amuniversal.com

Do you ever notice the way you feel when you're around animals, birds, or insects? When I watch bees hovering and flying from flower to flower, they seem to be content, or happy, at work. A hummingbird will buzz by, sipping nectar from the heart of a flower like a child sipping a favorite drink through a straw. Nature's creatures long ago affirmed that working, playing, singing, and socializing in balance are the keys to a joyful life.

We have an affinity for connecting with nature. The biologist E. O. Wilson calls the instinctive bond between human beings and other living systems *biophilia*. Nature inspires us to be happy by surrounding us with ladybugs, birds, and squirrels living their animal lives to the fullest, and it encourages us to do the same. The other day while I was stuck in traffic on the coast highway, I watched three large ravens flying in circular patterns, floating on the wind in the company and comfort of each other. Their soaring flight spirited me away from my own gridlock.

Whether it's the resilient dandelion that has the ability to grow and survive in the most adverse conditions, or the sweet sound of a bird's song, nature provides fuel for our souls—we need only find our way to connect with the magnificent and vast supply around us.

—Maryjo Koch

You have everything

you need to be happy.

Contentment is an *inside* job.

Well-being is grown

in one's own garden.

Joy
can spring like
a flower from
the most unlikely
places.

Happiness is a way to fly, not a destination.

Some create happiness wherever they go; others create it whenever they go.

Carry your happiness with you.

Enjoyment is found in the littlest things.

Joy comes in many colors.

Being happy is when you decide to overlook life's imperfections.

Like a rare bird, happiness alights upon the hand that does not grasp for it.

Happiness takes practice, like the violin.

Those
who wish to sing
always find
a song.

Don't wait for the storm to pass. Learn to dance in the rain.

Jumping for joy

is good exercise!

Be all that you can be, and you'll be happy.

We all smile in the same

language.

Pleasure is always doubled when it's shared.

Good spirits are a perfume you can't spray on others without getting some on yourself.

BE HAPPY TODAY

Success is getting what you want. Happiness is wanting what you get.

Someone far less

else is happy with than you have.

Happiness is admiring without desiring.

Bliss doesn't burn forever.

It's just a glow.

Happiness makes up in height for what it lacks in length.

Let gratitude be your attitude, and happiness is sure to follow.

The Nature of Happiness

Bees on a Rose

Happy are the bees where the flowers look good and smell good, too. They prefer flowers with shapes that provide them easy access to nectar, such as heirloom rugosa roses which have a sweet fragrance and open petal clusters.

Parrotfish

This brightly colored fish is named not only for its coloration but also for the shape of its parrot beak–like mouth that can rasp algae from coral and other underwater rocky surfaces. Native to tropical oceans throughout the world, they are found in coral reefs, seagrass beds, and rocky coasts. Some species of parrotfish are able to secrete a transparent cocoon made of mucous, which envelops their bodies, forming a protective bubble around themselves to deter predators and mask their scent. They also have large, thick scales that in some species are strong enough to repel a spear. They seem to have all the "tools" to live long, happy lives!

Honey Bee Inside a Flower

Bees are some of the most social of all insects, forming colonies whose members work busily to gather nectar from flowers to make their special food known as honey. Bees suck the nectar into special honey sacs in their abdomens where enzymes digest the natural sugars. After depositing the product inside wax honeycomb cells within a communal hive, bees fan it with their wings to speed the evaporation of excess moisture. The reduced liquid, eaten by both larvae and mature bees, is honey. Working daily from inside the flower to inside the hive, the honey bee's fulfillment is truly an inside job.

Honey Bees in Lavender
Honey bees love lavender and lavender loves honey bees! They have the perfect interdependent relationship as thousands of bees buzz busily from flower to flower, gathering nectar and pollen and pollinating the lavender as they go. The flavorful honey produced by the bees from the lavender nectar is highly prized by bees and humans alike.

Dandelion on the Rocks
The resilient dandelion has the ability to grow and survive in the most adverse conditions. Sprouting upright from almost any kind of soil or rock, it has a deep taproot that burrows downward, anchoring the plant above the surface. Even if the dandelion plant is plucked from the ground, the taproot soon resprouts, cheerfully blooming again with sunny flowers.

Flying Yellow-Faced Bumblebees in a Flower Garden
With a short, stubby body and small wings, the bumblebee doesn't appear very flight-worthy. It's hard to imagine how bees' little wings can generate enough force to keep them in the air. But the secret to their unique ability to fly is the unconventional combination of short, choppy wing strokes, a rapid rotation of the wing as it flops over and reverses direction, and a very fast wing-beat frequency. Bumblebees have adopted a "brute force" flying style powered by a huge thorax that is fueled by energy-rich flower nectar.

Clownfish and Shark
Colorful clownfish are welcome inhabitants of shallow waters and coral reefs because they protect reef dwellers such as anemones from parasites and predators, including butterfly fish. Anemones in turn protect clownfish from larger, hungry fish such as sharks and eels, by sheltering them inside their stinging tentacles, to which clownfish are immune. While sharks play an important role in the ecosystem of a reef, as large predators they are not a welcome sight to smaller fish in the ocean.

Hermit Crab
Unlike crabs with hard shells, this land- or water-dwelling crustacean has a soft, vulnerable abdomen. It must seek a secondhand, empty shell to live in and protect itself from predators. A hermit crab carries its shell wherever it goes, pulling itself around on several legs with its head outside the shell. When it outgrows its portable home, it switches to a larger one, when it can find one just the right size.

Ladybird Beetles
Also known as ladybugs, little ladybird beetles have long been regarded as the gardener's best friend because they eat plant-destroying aphids. Their distinctive spots and cheerful colors are much appreciated by humans but are meant to make them unappealing to predators. Insects and hungry birds that have made a meal of a ladybird will get a negative visual reminder the next time they spot its colors, of the foul-tasting fluid that ladybirds secrete from their leg joints.

Keel-Billed Toucan
This tree-dwelling native of the Central and South American rainforests is also called the rainbow-billed toucan, with good reason. From its multicolored bill to its striking, yellow chest, red tail feathers, and blue feet, its kaleidoscopic coloring is a joy to behold. The toucan's long bill is a wonderful piece of structural engineering. It is amazingly lightweight due to the hollow bones that provide its structure and is covered in a lightweight but hard protein (keratin). This unique bill is also good for grasping the toucan's favorite foods—fruit and seeds found high in the tree canopy of the rainforest.

Shoebill Stork
Native to wetlands of east-central Africa, the shoebill stork is an endangered species of large wading bird that feeds on fish, reptiles, amphibians, and small mammals in its freshwater marshy habitat. It's a solitary bird and rarely found in groups or pairs. They have a tendency to stand quite still for long periods of time and are almost completely silent except for their bill-clattering greetings, which they demonstrate while nesting. Their strong shoe-shaped bills are their most distinctive physical feature, allowing them to feed on larger prey than do other wading birds of similar size.

Red Bird of Paradise
The males of this rare, island-dwelling bird are exotically beautiful, with iridescent, emerald-green facial feathers, bright yellow mantles on their shoulders, large, fluffy, red plumage on their bodies, and two long, wiry, corkscrew-shaped black tail feathers. Native to the rainforests of the West Papuan Islands of New Guinea, the red bird has a spectacular costume that is crucial to a male's ability to attract a mate, and he uses his plumage to dramatic effect when performing his exotic courtship dance for choosy females. Once populous on these isolated islands, red birds of paradise have become endangered as their rainforest habitat becomes increasingly diminished by human encroachment.

Insect Concert
This fanciful homage to the nineteenth-century French caricaturist known by the pseudonym J. J. Grandville depicts an insect concert at a wedding party. Insects playing stringed human instruments such as violins and cellos remind us of the natural stridulation of crickets and the happy thrum of bees. Insects practice their "music" to attract mates and define their territory, delighting potential suitors and deterring possible enemies. Their rhythms fill the air in a sonic swarm, one of the great joys of spring and summer.

Song Sparrow
Found throughout every region of North America, the little song sparrow is one of the most abundant and adaptive native species of birds on the continent. It thrives in a variety of habitats, including human areas. Song sparrows have a colorful repertoire of songs, often learning songs of other birds in their territory. They can know as many as twenty different songs with thousands of variations.

Green Tree Frogs
Found throughout the central and southeastern United States, the diminutive green tree frog can be found wherever there is fresh or brackish water and plenty of floating vegetation, such as in ponds, lakes, marshes, and streams. At night they consume the many insects that also inhabit their watery habitat, such as mosquitoes, moths, flies, and crickets, often performing acrobatic maneuvers as they jump from stem to stem. During the breeding season from April to September, a chorus of loud nasal quacking sounds can be heard as males call to expectant females. The quacking also occurs right before a summer rain starts and is known in some regions as a "rain call," tempting some people to regard these brilliantly colored frogs as the best weather forecasters around!

Five-Lined Skinks
The most common lizard in eastern North America, the five-lined skink grows to be eight inches long and has five light stripes down its dark body. Young skinks have bright blue tails. They are ground-dwelling reptiles found in moist woodlands where they forage for insects. Occasionally, they can be found climbing and jumping onto decaying trees or basking in the sunlight. If confronted by predators such as birds, snakes, or small mammals, skinks are quick to take refuge in crevices. They also have a unique defense mechanism: they can disconnect their tails during flight. Because the tail is brightly colored and twitches even when it's detached, it distracts a predator long enough for the skink to run away.

Happy-Face Spider
Native only to the lush tropical forests of the Hawaiian Islands, tiny happy-face spiders sport a variety of body colors and distinctive face-like markings. Many look happy-faced, while some appear to be frowning, and others resemble "aliens." While the smiley-face markings may seem friendly to humans, they are actually protective markings to confuse predators. In recent years, the happy-face spider has gained special celebrity status and become the symbol of all of Hawaii's threatened native species. Representations of this infectious-smile-producing arachnid can be seen on T-shirts, baseball caps, postcards, and vehicles.

Woodland Creatures on a Branch
(Left to right: red squirrel, bumblebee, green valley grasshopper)
Are creatures happy? From a biological standpoint, it has been observed that happiness is a form of pleasure and an important means of survival, just like fear and pain. Whether pleasure or pain, nature rewards behavior that helps creatures to survive.

Woodland Creatures on a Branch *(continued)*
(Left to right: house mouse, large blue butterfly, green tree frog, dark-lipped banded snail, wooly bear caterpillar, two-spotted ladybird beetle, Eastern bluebird)
In the animal world, eating and mating produce feelings of contentment ensuring that species quickly learn to feed themselves and reproduce. But what about things like joy and play? Biologists have observed that these successful behaviors also appear to be enjoyable in themselves and are an important way of building physical strength, coordination, and social skills. So, as with humans, there appears to be joy of life in the wild.

Welsh Corgis
Playful and fun-loving, corgis are also skilled herding dogs that originated in Wales. They have medium-sized, sturdy bodies and short, strong legs. When herding, they work from behind the livestock, nipping at their heels to move them forward. Corgis are quite active and energetic, and enjoy having another corgi buddy.

Striped Skunks
A skunk's special "perfume" is a well-known defense against potential enemies. The foul-smelling odor it produces and sprays from scent glands beneath its tail is strong enough to ward off a bear and can travel as far as ten feet away, hitting its target with surprising accuracy. A skunk usually will not spray other skunks, but its spray is so effective that most animals give it a wide berth. The odor can last for many days and is not easily removed.

American Red Squirrel
Three species of red squirrels can be found throughout North America. A small squirrel, slightly larger than a chipmunk, the red squirrel has reddish fur and a white underbelly. Although their diet consists mostly of the seeds from conifer cones, red squirrels are also content to eat berries, nuts, mushrooms, insects, flowers, and leaves. When cones and nuts mature, red squirrels harvest and store them in the ground or under logs to feed on during the winter months.

Green Tiger Beetle and Honeypot Ant
Some insects are voracious feeders while others are fed to be storehouses for their colonies. The iridescent green tiger beetle is long-legged and runs very fast. It is a fearsome predator of other invertebrates throughout Eurasia. In contrast, the honeypot ant is a "living larder" whose unique body is used to store food for the ant colony by fellow worker ants. As the workers feed the honeypots more and more food, their abdomens swell and they lose their mobility. Later, when food is scarce in the semi-arid environments they call home, such as the southwestern U.S., Mexico, Australia, South Africa, and New Guinea, they are able to release their stores of food, providing a vital source of nutrients and water to their nests.

Peacock and Bewick's Wren
The three main species of peacocks are native to Asia and Africa. Blue- or green-bodied Indian peacock males have resplendent, iridescent train feathers that spread in a fan formation when courting the less colorful peahens. Their plumage above their tails is made up of more than 200 feathers, each tipped with stunning eyespots. In contrast to the small, grey-brown Bewick's wren, a displaying peacock is a showstopper! But the wren has one up on the showy peacock—its song is melodious, while that of the peacock resembles a shrieking howl. The Bewick's wren is native to the western and mid-western United States and Mexico, and is named for the nineteenth-century English engraver Thomas Bewick, a friend of the famous American bird artist John James Audubon.

Fireflies
Fireflies are winged beetles known for their conspicuous use of bioluminescence to attract mates and lure prey. They display unique flashing patterns and different species of fireflies recognize each other by their flashing signals in the evening or nighttime. Certain species of fireflies can even synchronize their flashing patterns precisely, as thousands blink in unison for a few weeks in early summer in temperate and tropical environments.

Giraffe
Giraffes are the tallest living animals on earth, between 16 and 20 feet tall. They are native to the savannas and woodlands of central, eastern, and southern Africa. Their long legs and extremely elongated necks (up to 6 feet long) enable them to feed happily on their favorite food: twigs and leaves from woodland treetops inaccessible to other grazing animals. They consume up to 75 pounds of foliage a day. They also have extremely long tongues, about 21 inches long, which are useful for grasping foliage in hard-to-reach spots. The giraffe's height also helps it keep a lookout for predators across the wide African savanna.

Emperor Penguin and Chick
Emperor penguin chicks have a lot to be grateful for. After hatching in the freezing Antarctic climate, they are entirely dependent on their parents for warmth and food. Their parents take turns traveling dozens of miles over the icy terrain to find fish to bring back to their hungry offspring. While the chicks are still very young, they spend their days balanced above the ice on their parents' feet, sheltered inside a brood pouch until they are old enough to huddle together with other chicks for warmth and protection.